TICK TOCK TICK TOCK TICK TOCK TICK TOCK TICK TO

ck *tick* **tock** *tick* **toc**

D0382386

TO THE MEMORY OF TONY HANCOCK, WHOSE BRILLIANT COMEDY TIMING REMAINS UNEQUALLED.

A Fillip Book.

Captions copyright © 1993 by Philip Collins.
Photographs copyright 1993 by Garry Brod.
All rights reserved. No part of this book may be
reproduced in any form without written
permission from the publisher.
Printed in Japan
ISBN 0-8118-0278-7
Library of Congress Cataloging in Publication Data available.
Book and cover design: Karen Smidth
Composition: On Line Typography
Cover photograph: Garry Brod
Distributed in Canada by
Raincoast Books
112 East Third Avenue
Vancouver, B.C. V5T 1C8
10 9 8 7 6 5 4 3 2 1
Chronicle Books
275 Fifth Street
San Francisco, California 94103

**General thanks are due
to all clocks owners credited
in this book.**

Particular thanks are due to:

Howard Banta

Garry Brod

Martin Carlin

Dennis Clark

Peter Linden

Eric Menard

Marc Schwartz

Larry Spilkin

Kay Tornborg

Ben Yellin

P H I L I P C O L L I N S

PASTIME

T E L L I N G T I M E F R O M 1 8 7 9 T O 1 9 6 9

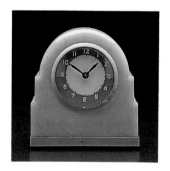

PHOTOGRAPHY BY GARRY BROD

C H R O N I C L E B O O K S

SAN FRANCISCO

tick toc

when minutes matter
...trust TELECHRON
ELECTRIC CLOCKS

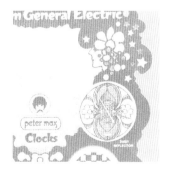

tock *tick* tock *tick* to

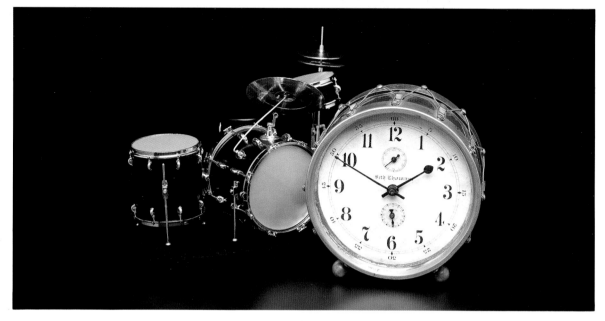

A Seth Thomas table clock
as a bass drum with wall
mounting attachment in
nickel and brass, patented
on September 9, 1879,
by the designer, George
Muller. The movement
is wind-up with an alarm
mechanism.

Howard Banta Collection

Ben Yellin Collection

WHEN DUNBAR, a bombardier in Joseph Heller's *Catch 22,* is not dodging air battles over Europe or dropping bombs where they won't hurt anyone, he spends as much time as possible on his airfield's skeet-shooting range. It's important to remember that Dunbar actually loathes skeet-shooting—but he also loves it, because it's so boring. Dunbar craves boredom to staunch the relentless rush of time, allowing him at least the illusion of living longer. Of course, Dunbar is not the only character—literary or real—who had problems with time. Even children are not immune to its force. In *Peter Pan,* the villainous Captain Hook admonished his audience to "slow time down, laddie." And although a few reflective people may be somewhat unsettled by time's inevitable flow, seeking order in the Bible's dictum that there is "a time to every purpose under the heaven," most of us seem to accept the passing of the years as just one more aspect of life's events over which we have no control.

Philosophers, poets, playwrights, even rock singers have given the world countless metaphors for time, seeing it in various guises—as destroyer, rider on a winged chariot, envious hag, or eater of

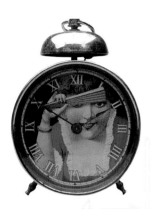

A German nickel clock in a "dust free" case from the late 1890s. This rare and fine example of the "Flirt" clock, an animated novelty alarm wind-up with bold Roman numerals, is a collector's classic. The flirt's cherubic face, printed on paper by litho process, is regularly masked by the fan, which articulates from her pivoted wrist and hand.

Ben Yellin Collection

cormorants. Indeed, we have been graced with many trenchant opinions about time, but we should not forget that most people actually don't have the time to think much about time. Given our meager allotment, we must use time to good advantage. That is where clocks come in.

Whereas time continues to slip through our fingers like…well, sand…we can actually put our hands around clocks. Solid and simple collections of dials, metal, and plastic, they can be put to useful purposes. They are functional and may be chosen as much for style as for mere usefulness. But clocks seldom seem to inspire passion in most people. Sure, they're handy and a little decorative, but what else do they do?

For one thing, clocks can entertain and instruct. Much more than simple devices designed merely to divide time into hours so that we may plan our busy schedules, they are also examples of culture and science and art. *Pastime* presents us with a collection of clocks—an astonishing, fascinating variety—reflecting the fads, cultural icons, and technology aimed at clock enthusiasts of previous generations.

RIGHT

Nickel wind-up clocks from the turn of the century featuring full-color illustrations on printed litho cards. A pretty young girl's tongue ticks into view in a design from 1887 (TOP). The washer woman scrubs away as the hands turn. An American design from the Water-bury Clock Co. (CENTER). The wind-up alarm from Germany, c. 1915, was advertised as "the Negro," whose eyes swivel left to right and back in time with the seconds (BOTTOM).

Ben Yellin Collection

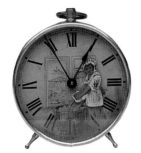

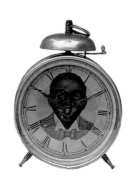

Before the invention of clocks, time was measured by the fall of light upon megalithic stones, or by the length of a shadow upon a tree. Approximately three thousand years ago, the Chinese invented the water clock, which used liquid to record the passage of time. Eventually, the sundial came into being, initially as a decorative device for measuring shadows. Soon the sundial became more than merely a means of telling time— it was the design centerpiece in many gardens, around which trysting, plotting, or merely talking out of the range of inquisitive ears took place.

In the fourteenth century, the first "modern" clocks appeared, possessing the basic mechanical elements that would power clocks for the next four hundred years. These early devices kept adequate track of time, but because they were not precise, they were not entirely satisfactory. Precision became increasingly important as European nations began to explore the world's oceans, exact time-telling being a fundamental component of the developing science of navigation. In the 1700s, the English government even offered a substantial cash prize to any inventor who could produce a clock

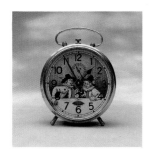

accurate enough to help ships plot their route through trackless seas.

The harnessing of electricity in the nineteenth century provided new methods to control clocks, allowing manufacturers to produce smaller, more accurate timepieces. With scientific advances in the twentieth century, we have developed amazingly precise timekeeping instruments, yet we are probably no closer than our ancient forbears to fully comprehending the fundamental nature of time.

Outside the laboratory, clocks have long been both functional and decorative. In previous centuries, they were often huge and staggeringly ornate, ranging from towering monoliths such as Big Ben to complex prodigies like the Great Clock of Strasbourg Cathedral, which offers the faithful not merely the hour but also the position of the heavenly bodies, the day of the month, a procession of gods to denote the days of the week, and a parade of apostles—announced by a crowing cock— to mark each day's noon.

In this century, many clocks continue to reflect society's cultural values and scientific expertise. Some may represent simply the eccentric aesthetic

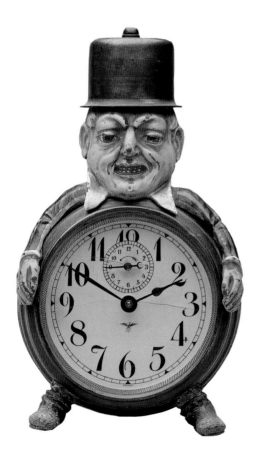

taste of their makers. Others—such as the samples in this book—have become prized by collectors. Valued collectible clocks are the focus of *Pastime,* in which the reader will find a wonderful selection of interesting clocks, many fashioned in the four decades following World War I, and each possessed of a value beyond its simple mechanical ability to keep track of the hours, minutes, and seconds of our days. Pastime is an appreciation of the craftsmanship, style, whimsy, and common cultural heritage revealed in the design of clocks.

These are timepieces of infinite variety and fancy, reflecting the tastes and interests of their owners. Here the reader will find a brief survey of twentieth-century design ideals, from refined, almost Baroque styles emulating birdcages to spare, contemporary forms that imitate the lines of modern furniture. Several are stark in their appeal; some look as though they were toys; and others evoke the 1950s, when automobiles sported chrome fins and America seemed poised for unlimited greatness.

In *Pastime,* the reader will discover clocks posing as miniature skyscrapers, airplanes, rockets, ships, and starbursts. Scottie dogs, German

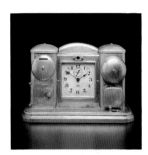

burghers, nymphs, and sheep are stretched and
shaped to accommodate a round dial, twelve num-
bers, and two or three moving hands. There are
clocks for the kitchen in the shape of teapots, and
clocks for kids with the faces and figures of Mickey
Mouse, Popeye, and Bugs Bunny. Charlie McCarthy,
the most popular radio comedian of the thirties,
boasted his own clock. Several clocks perform mul-
tiple functions, from telling time to starting the
morning coffee. Others proclaim their owner's
avocations, resembling a tennis racquet, a bowling
pin, or a yacht's steering wheel. There are clocks
with faces in them, and faces with clocks in them;
clocks of plastic and metal; clocks beautiful in
their simplicity or astonishing in their complexity.

These clocks project a presence, a sense of
purpose and place that is heightened by the fact
that their fundamental role is to reveal the time of
day and to record its passage. Beyond these simple
duties, the clocks also seem to have drawn into
themselves the essence of the era that produced
them. Thus, a Streamline design evokes modernity
and optimism just as surely as its contemporaries,
the Tom Mix or Roy Rogers clock, recall the heroic

ABOVE

Two original boxes for
wind-up alarm clocks from
Ingraham. The box tops bear
the legend "Made in this
Modern Plant by Skilled
American Craftsmen." The
box at left housed a one-day
"Ace" alarm wind-up. The
"Time Square" clock retailed
at $2.19, according to
the original sticker price
attached to the bottom.

Ben Yellin Collection

and simple era when those stalwart characters and
their uncomplicated sidekicks represented the best
and most noble elements of their age.

These are manufactured objects, the products
of contemporary factories and skilled technicians.
Great industrial enterprises such as General Electric,
New Haven Clock and Watch, Telechron, Sessions,
Ingraham, and Borg produced clocks by the millions,
and their advertisements and company histories,
which form important pieces of background infor-
mation for the collector, are also of interest.

In the shape of clocks, the reader will find a
stylish design or a bit of fantasy to disguise the unre-
lenting passage of the hours. These are not objects
for philosophical contemplation but for enjoyment.
They are functional and often chic, enhancing our
decor and providing us with the rewards of years of
collecting. In Pastime, the clocks seem to have ar-
rested time, however briefly, giving us, in their many
shapes and visages, a pleasant, visual excuse to ask
the time of day.

1

9

FISH GLOBE

2

REVOLVING
ANGEL-FISH

TICK Tock TICK Tock TICK Tock

SECOND HAN

0

PL
BA

s

WOOD OR PLASTIC SUB-BASE

5"

CLOCK WORKS

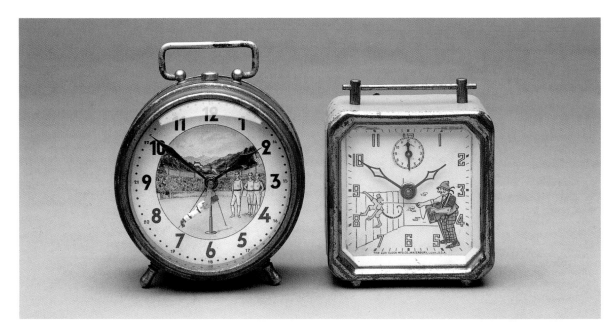

ABOVE LEFT

A novelty nickel wind-up alarm of unknown origin. The graphics depicting competing athletes at the parallel bar may have commemorated an Olympiad.

c. 1920.

Howard Banta Collection

ABOVE RIGHT

The organ grinder's arm turns the handle in perpetual motion on this Lux novelty wind-up, retailing at $.90 in the year of its introduction.

Courtesy, Off The Wall, Los Angeles

PAGE 17

Originally patented in 1926 by J. Oswald of Freiburg, Germany, this wooden Scottie dog tells the time with its eyes. The red lines running from the center of each pupil point to the appropriate marking at the edge of the eye socket. The hours are marked around the left orbit and the minutes around the right. Variations of this carved pet include Pekinese dogs, owls, and turbanned women.

c. 1929.

Ben Yellin Collection

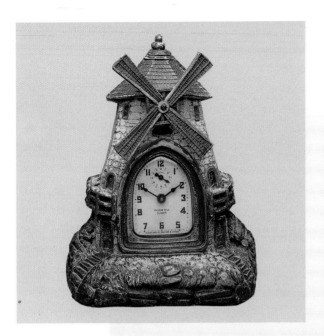

A novelty "Village Mill Alarm" manufactured by Jackson Manufacturing of New York and Chicago, this design incorporates a thirty-hour Lux "non overwind" movement and was advertised as being produced in "an unbreakable wood product" in "natural colors" with a design patent first registered on April 27, 1920.

Howard Banta Collection

A curiosity in the shape of a storefront replica, produced by Regent Manufacturing, Chicago. This wind-up alarm clock set in a heavy bronzed casting suggests a place in the hearth where the fire flames can be clearly viewed through the windows and sconces. A specialty gift item from the store that advertises itself, Warner's Clothing House of Sandwich, Illinois.
c. 1920.

Howard Banta Collection

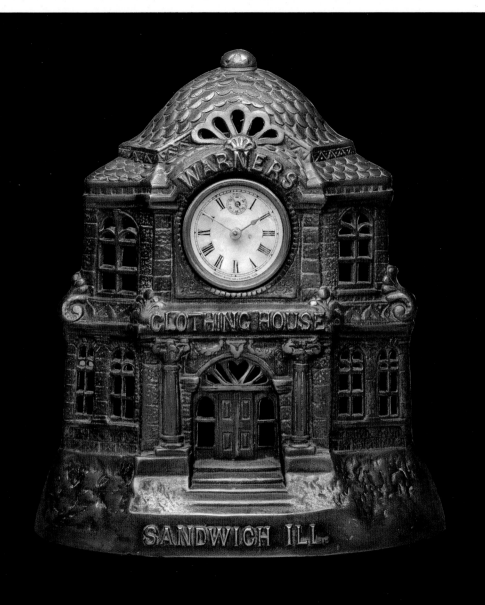

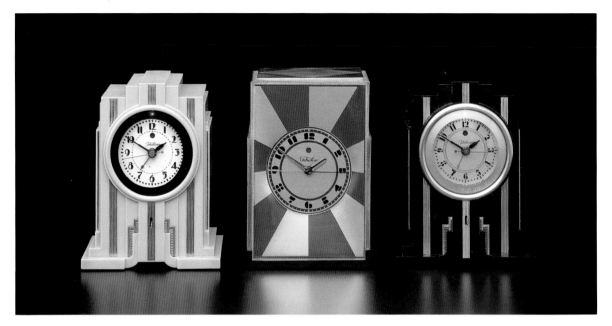

The Warren Telechron
Company of Ashland,
Massachusetts, distinguished
itself in the thirties and
forties by offering reason-
ably priced, beautifully
designed timepieces, often
created by notable industrial
designers. An exception
to their modern pricing
was the "Fifty Dollar Clock"
(CENTER) produced in dif-
ferent metals. Options
were the brass finish shown
here, burnished silver,
chrome and black, or
chrome and navy. c. 1927.

Two Paul Frankl designs—
skyscraper-illuminated
alarm clocks in Vinylite
plastic—were in the
Telechron range from 1927
to 1936 (RIGHT AND LEFT).
Peter Linden / Eric Menard Collection

"The Fish Globe Clock,"
a Japanese-made wind-up
from the late twenties.
A revolving ball indicates
hours and minutes while
one moving fish ticks out
the seconds. The second fish
oscillates in a fixed position.
This elaborate design was
adopted for use in an adven-
turous how-to (build your
own) book of the period.
Peter Linden / Eric Menard Collection

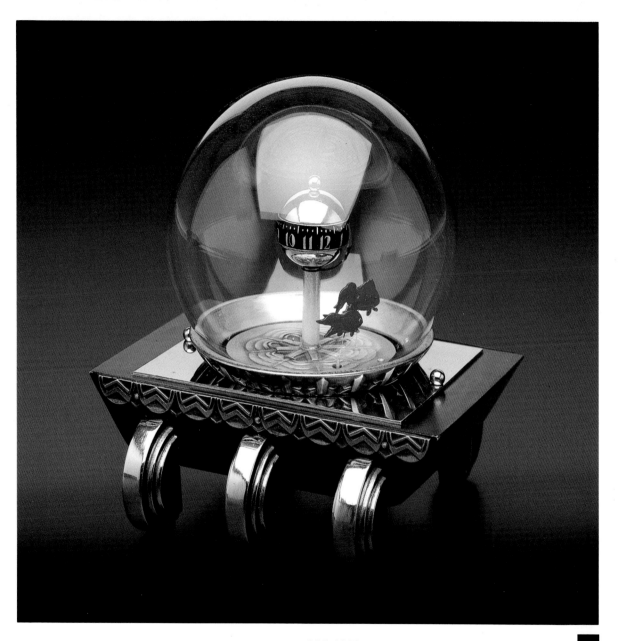

Fig. 1.

1 9 3 0

s

TICK *TOCK* TICK *TOCK* TICK *TOCK*

MON

JUN

28

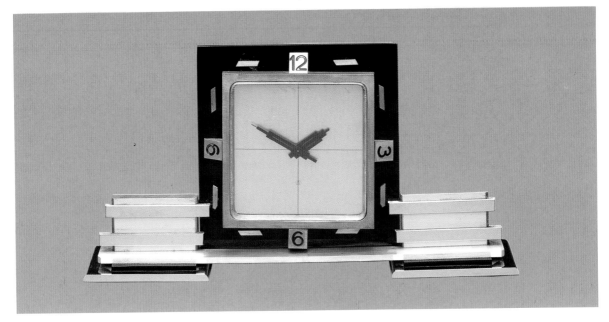

ABOVE

A French mantel clock
from the thirties, featuring
a fifteen-jewel Swiss
movement. This wind-up
features an aluminum
case mounted on a black
Lucite panel, with trim
in chrome and brass.

Courtesy, Harvey's, Melrose Avenue

PAGE 25

Inexpensive plastic-cased
wall clocks for the kitchen
from the thirties in
traditional red and white
"kitchen colors." Three
manufacturers are rep-
resented: Telechron
(TOP AND BOTTOM LEFT);
National (TOP RIGHT);
Westclox (BOTTOM RIGHT).
A Sessions "Chef" from the
fifties (CENTER) presides
over his earlier non-figural
kitchen counterparts.

Courtesy, Wanna Buy A Watch?,
Melrose Avenue.
Center, Rebekha Brod Collection

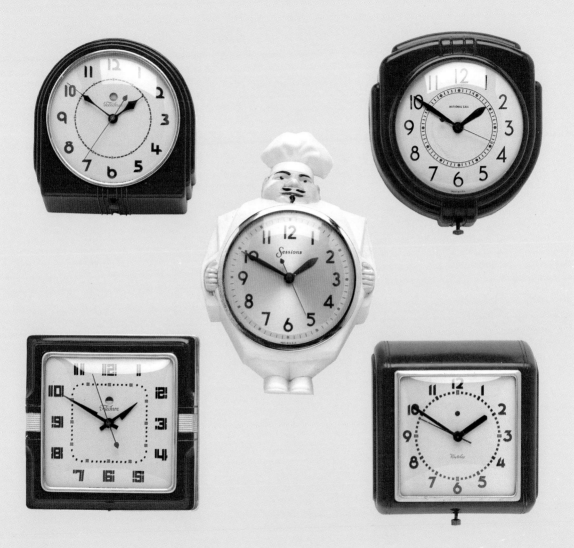

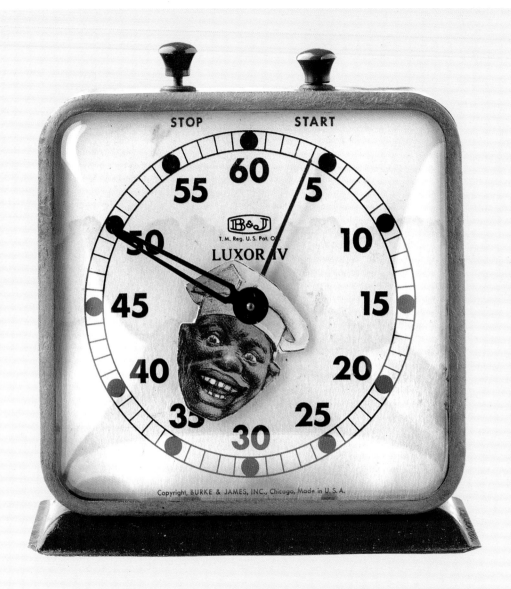

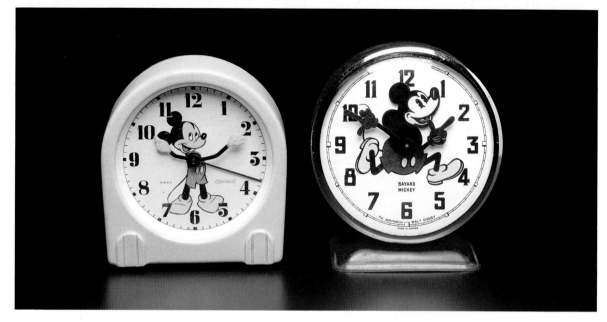

An early thirties kitchen
timer from Burke & James
Inc., Chicago, sold under
the Luxor banner. The
animated chef turns through
360 degrees as the second
arm revolves. The minutes
of elapsed time are recorded
with a conventional clock
hand.

Ben Yellin Collection

ABOVE

In 1930, the world's most
famous animated character
appeared for the first
time in the sound cartoon
"Steamboat Willie." For
the last sixty years, Mickey
Mouse has reigned as the
most merchandised creation
on the planet and probably
the most internationally
recognized. An Ingersoll
wind-up alarm (LEFT) in a
plastic case from the sixties
is predated by a French
Bayard model (RIGHT) in
an all metal case that was
produced from 1936 to
1969. A subtle change in

the later rendering is
Mickey's high-glance eyes.
The early Mickey sported
"apple pie" eyes.

Left, Howard Banta Collection
Right, Courtesy, Off The Wall,
Los Angeles

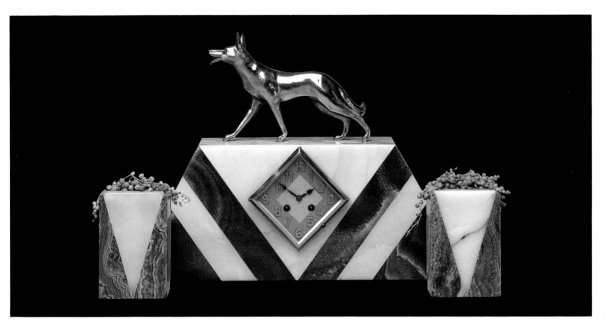

Wind-up clock sets from France (BELOW, RIGHT) and England (ABOVE) in finely veined marble and onyx with classic art deco motifs. A design by Feyral (PAGE 29) featuring a silver-plated pewter nymph on a marble base is from France, c. 1930. An extraordinary variety of marble mantel-clock sets was offered by European manufacturers through the thirties. They invariably featured figurals of Aztec and Amazon women (many sculpted by Ferdinand Preiss) and exotic animals. In 1933, a less adventurous range was marketed by Hammond, a U.S. manufacturer, for affluent buyers whose tastes for marble could be satisfied by $40 to $60 clocks. The American range had electric AC current movements, and were sold as sets or as clocks without side oraments.

Courtesy, Harvey's, Melrose Avenue

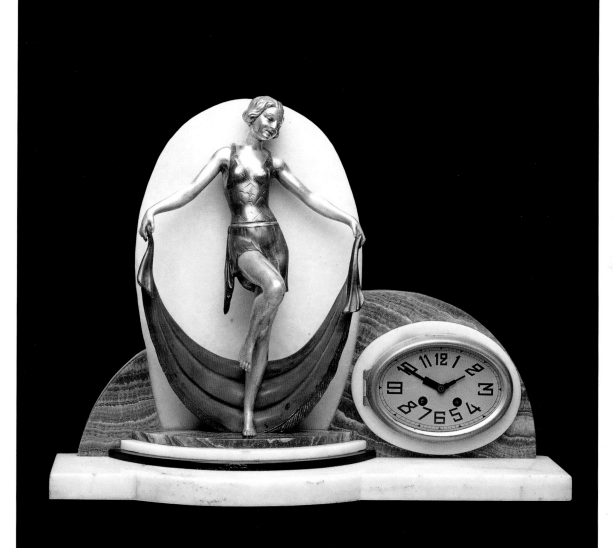

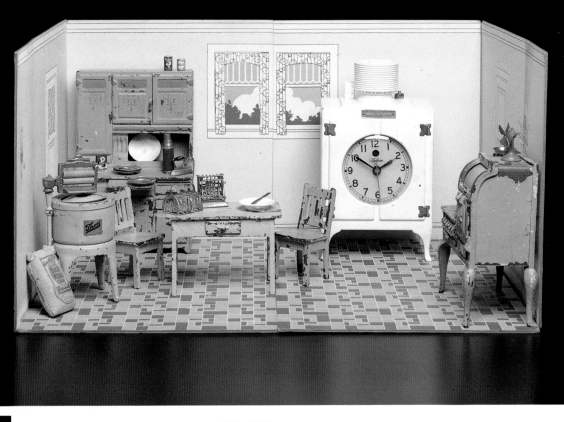

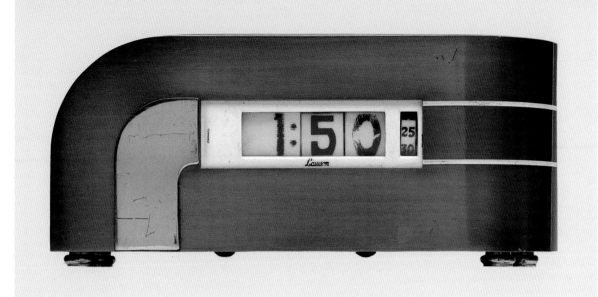

The General Electric "Monitor Top" refrigerator, introduced in 1931, was described as "a simple modern mechanism, hushed in a blanket of oil, sealed in a fortress of steel against time and wear." The Telechron "Refrigerator" clock is based on a refined version of the 1931 design. The case is all metal and is clearly created for the modern kitchen.

The Warren Telechron Company, a prolific clock manufacturing company, was taken over by General Electric in 1946.

Clock: Courtesy, Off The Wall, Los Angeles

Dollhouse Furnishings: Courtesy, Kay Tornborg

Manufacturing under the series "Lawson Timetable Time," Lawson Time, located in Los Angeles, produced a startling range of quality desktop numeral clocks at luxury prices during the thirties. The Zephyr, model #304, is metal cased with a golden brushed brass finish and brass trim (TOP). The designer is Kem Weber. It was also available in gun metal with a chrome finish, and weighs five pounds. Another design by Kem Weber for Lawson, in copper and brass trim, featuring vertically rotating numerals painted on ivory plastic wheels appears below.

Top: Courtesy, Harvey's, Melrose Avenue

Bottom: Courtesy, Off The Wall, Los Angeles

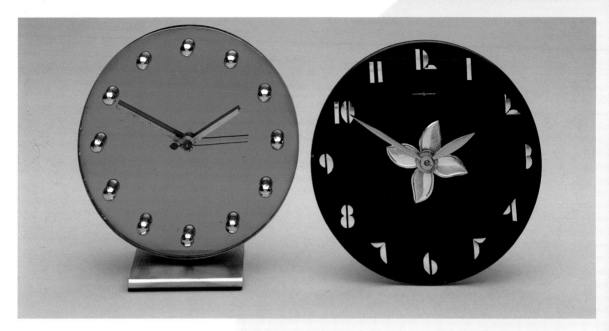

A Gilbert Rohde design
(LEFT) for the Herman Miller
clock company featuring
symmetrical chrome spheres
against a blue mirror on a
chrome base, c. 1933.
General Electric model
#5F52 (RIGHT) has elegantly
styled minute and hour
hands. The stylized numerals
in this model were incorpo-
rated into many GE models
featuring a wide range of
mantle shapes.
c. 1934.

Peter Linden /

Eric Menard Collection

A back-lit frosted glass facia
mounted on a three-tier
aluminum pedestal features
numeral and arm design
derived from many General
Electric models. This exam-
ple, model #7H92, features
an alarm and is attributed
to Rockwell Kent.
c. 1934.

Peter Linden /

Eric Menard Collection

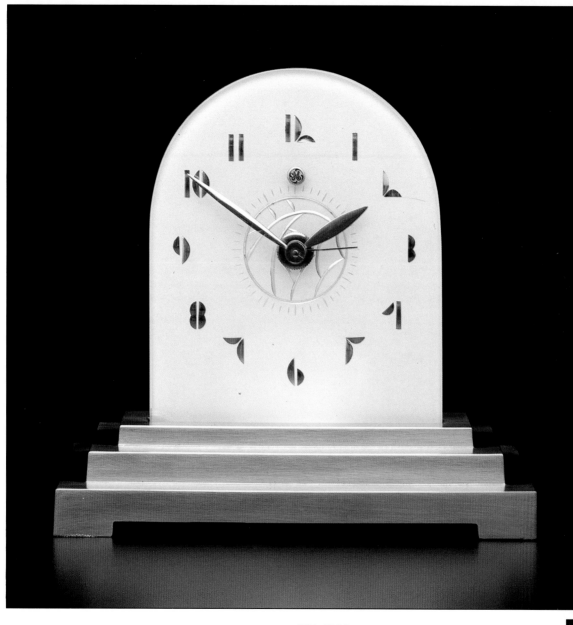

The "Numeral" desk clock style was produced in impressive numbers by the Lawson and Pennwood companies. This example in a simple, elegant brass housing with copper relief was made by General Electric in the late thirties. Model #8B22.

Peter Linden /
Eric Menard Collection

GC7757 Pennwood Numeral Clock, without pens..................... $19.90
GC7757A Two 14 Kt. Green Pearl Moore Pens, as Illustrated......... 6.00
A modernly styled clock that will add a note of distinction to any desk.
Black finished plastic case and base with crystal clear Lucite vanes.
Equipped with Parkette pen holders. Self-starting electric movement. Height
4½ inches. Length of base 14½ inches, depth 4½ inches.

The Mass Clock, a painted wood-case wind-up from 1934 with alarm. The hour hand is inscribed "350,000 Masses each day." The minute hand is inscribed "4 Chalices lifted up each second." The legend at the base reads, "MASS CLOCK PRAYER FOR EVERY HOUR: ETERNAL FATHER, through the Immaculate Heart of Mary, I wish to unite myself with Jesus, now offering his Precious Blood in the Holy Sacrifice of the mass, in *'name country'* for the needs of Holy Church, the conversion of sinners and the relief of the souls in Purgatory. Amen." Instructions on use include, "If it is P.M. where you are, the DARK SECTION on dial indicates the place in the world where Mass is then being offered. For instance if it is 5 P.M. where you are Mass is being offered in China. The Hour Hand points to where the Mass is being offered. If it is A.M. where you are, then look at the LIGHT SECTION."

Howard Banta Collection

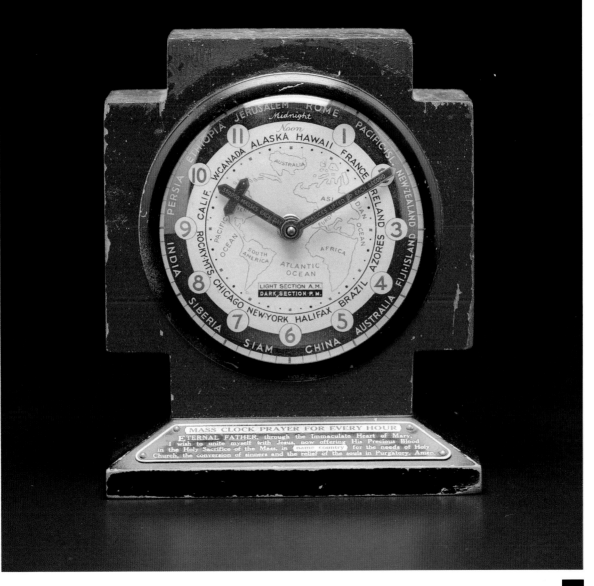

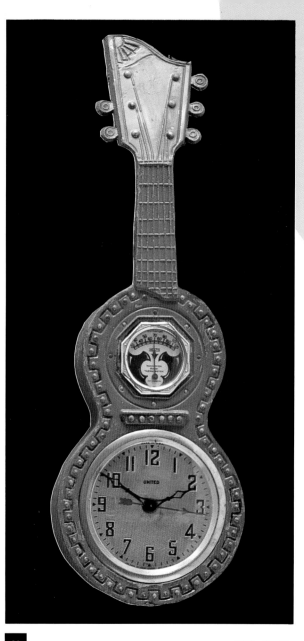

Stylized wall clocks in the form of musical instruments, particularly strings, reflect the popularity of musical taste through the latter decades of the twentieth century. This early example, advertised in a Montgomery Ward catalog, was produced in painted pot metal. The "ukelele" featured a room temperature thermometer and was available in gold, walnut, or ivory. A further option was a choice of wind-up or electric movements.

c. 1934.

Courtesy, Harvey's, Melrose Avenue

A classic desk clock in brass and copper from Lawson. Independent illumination affords a large spread of light beyond the clock area. Lawson Time Company employed talented industrial designers for their products. It is speculated that this model, #812, was created by a renowned artist.

c. 1935.

Dennis Clark Collection

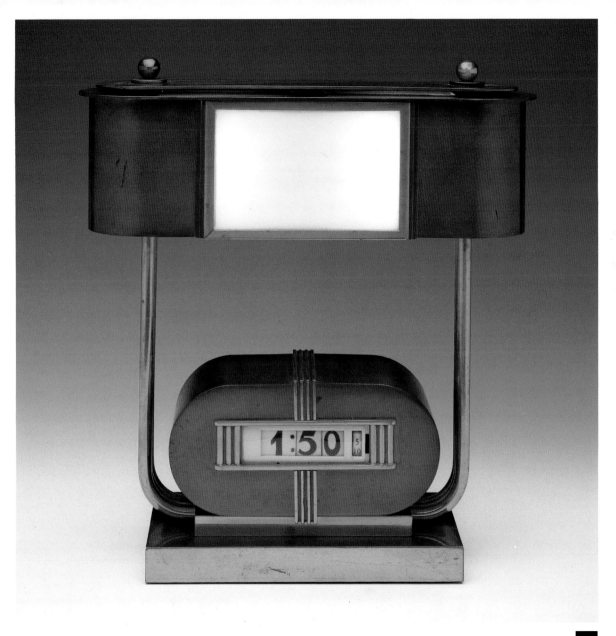

A

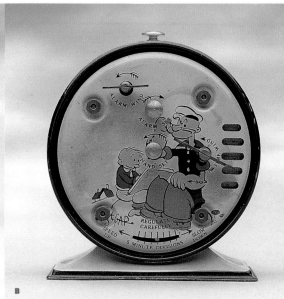

B

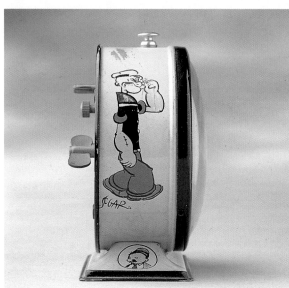

C

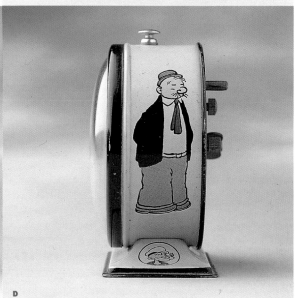

D

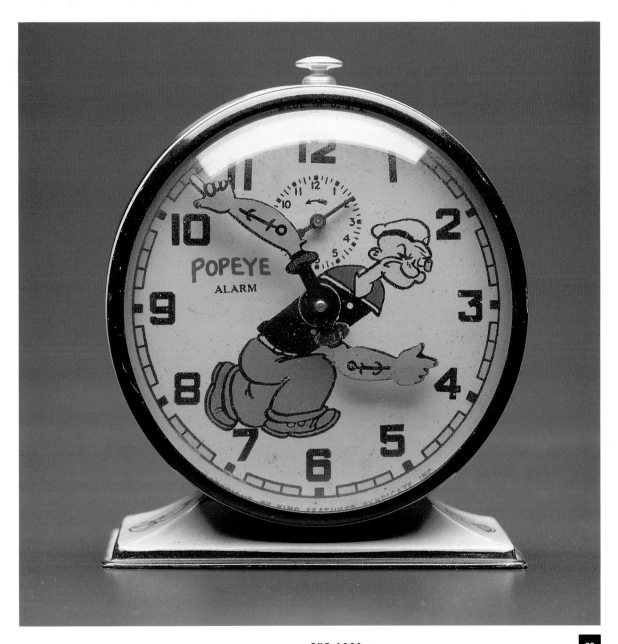

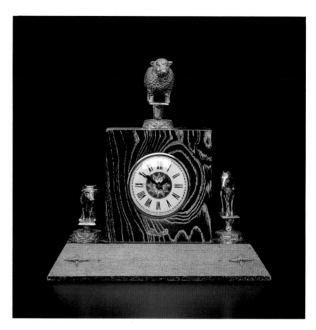

PAGE 38 AND 39

The quintessential children's wind-up alarm clock, manufactured by New Haven in 1934. An ivory-colored metal case with black trim houses an illustration featuring Popeye's muscular arms revolving to indicate the time. Full-color renderings of Popeye and the gang occupy every available space around the case. The bottom of the base has the faces of Fadewell, Olive Oyl, and Roughhouse above the text of the New Haven Guarantee. At the rear of the case, Popeye and a pal are behind the winding keys. Popeye and Wimpey are on the sides and base panels.

Ben Yellin Collection

ABOVE

A wood cabinet in black stained veneer finish with chromed metal sheep, bull, and horse ornaments. c. 1935. Manufactured by Lanshire, this self-starting clock suggests a customized presentation edition.

c. 1935.

Courtesy, Off The Wall, Los Angeles

PAGE 41

The "Glo-Dial" features a hoop of colored neon behind the numerals to illuminate the hands. A range of colors was available, and the style was adapted for advertising on store counter displays with customized messages applied to the face. The case is chrome with a copper base, and the neon light operates independently from the clock's electric drive.

c. 1935.

Courtesy, Piccolo Pete's, Sherman Oaks

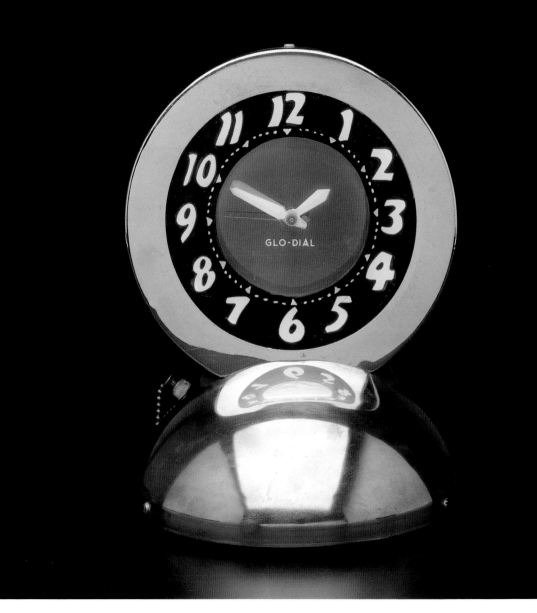

The Catalin Corporation produced a unique plastic compound in the mid-thirties that was popular for its lustrous gemlike finish and astonishing array of bright, swirled colors. The translucent quality of the plastic was exploited to advantage by the Lackner "Neon Glo" Clock Company of Cincinnati, Ohio, which produced this model in a variety of colored cases.

The "glo" is produced by a neon hoop, which is activated independently of the clock's electric motor.

Author Collection

An eight-day clock manufactured by Shreve. The wind-up mechanism is housed behind the face. The clear glass housing and tiered chrome frame support create the illusion that the clock face is floating in air.

c. 1935.

Peter Linden /
Eric Menard Collection

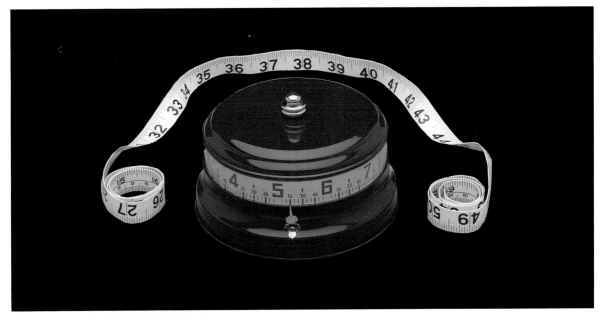

Designed by Herman F. Lux, for the Lux Clock Company in 1935, this rotary clock is one of a number of "tape measure" designs for the desk. Still selling in 1941 for $2.49, the metal cabinet with brass trim was offered in the three colors illustrated—Monterey Blue, Moderne Black, and Mandarin Red. As the tape slowly rotates, the time is indicated by a small pointer affixed to the base of the case. The movement is a pin pallet. Similar models were marketed in this period as the "Wywurrie" clock.

Courtesy, Regency Jewelry Company, Los Angeles

A porcelain Pierrot adorns a New Haven clockface and wind-up movement.

c. 1936.

Courtesy, Off The Wall, Los Angeles

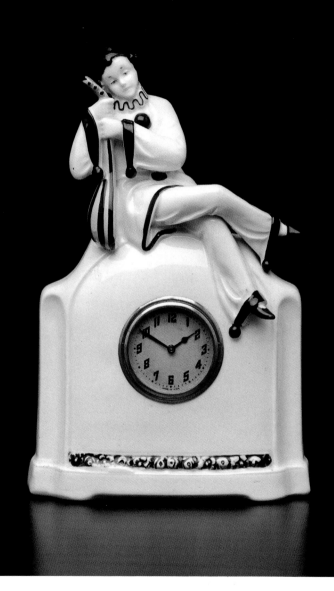

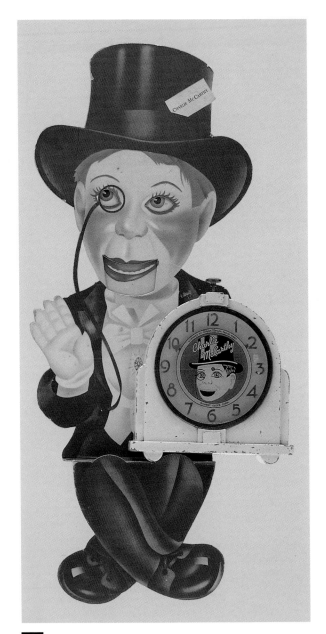

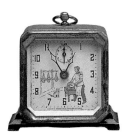

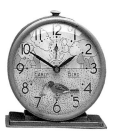

LEFT

A metal-case novelty clock manufactured by the Gilbert Clock Corporation. Charlie McCarthy is illustrated on a plastic lens behind the clock glass. The hour and minute hands peek out from behind the illustration. It is a mid-thirties example of an enormous range of merchandising that promoted radio's most popular comedian (along with Edgar Bergen). The clock features an alarm option within its wind-up mechanism.

Howard Banta Collection

ABOVE, TOP

A butcher chops away at a ham while his cat looks on. A novelty clock from August C. Keebler with wind-up movement.

c. 1935.

Ben Yellin Collection

ABOVE, BOTTOM

The Early Bird wind-up alarm is a collector's favorite. The bird bobs its beak to the ground to pull on a reluctant worm sixty times a minute!

c. 1935.

Ben Yellin Collection

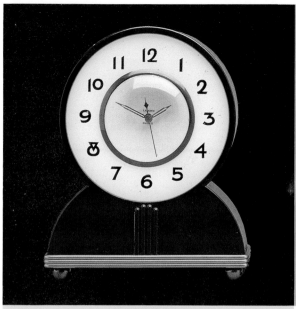

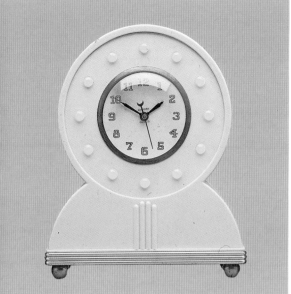

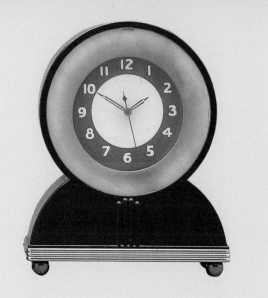

THIS PAGE

In the late thirties, the Lackner Clock Company in Cincinnati, Ohio, produced a range of "Neon Glo" clocks for the shelf or mantle. Housed in plastic cabinets, they featured different colored neon hoops and face designs, within the generic "Iris" cabinet design, pictured here. The illumination can be activated independently to give the clock a "day" and "night" appearance.

Author Collection

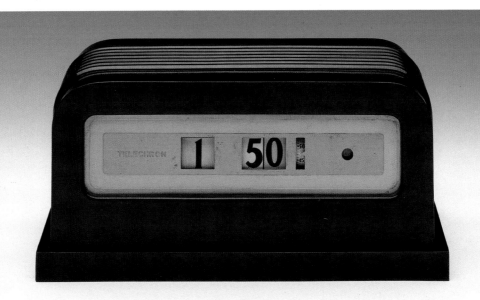

Designed by Walter
Dorwin Teague in 1937 as
a "Cyclometer Clock" and
produced by the Telechron
company in walnut Bakelite,
this example of superior
Streamline Moderne design
was copied by many manu-
facturers who incorporated
minor cosmetic changes to
housings that accommodated
the rotating digital wheels.
Model #8B07.

Courtesy, Regency Jewelry Company,
Los Angeles

A rare and unusual model
from Lawson Time, the
Highboy, model #410 in
bronze with brass trim, was
also available in satin silver
or gunmetal with chrome
trim. Seven inches high, the
clock has a shipping weight
of seven and a half pounds.

c . 1938 .

Dennis Clark Collection

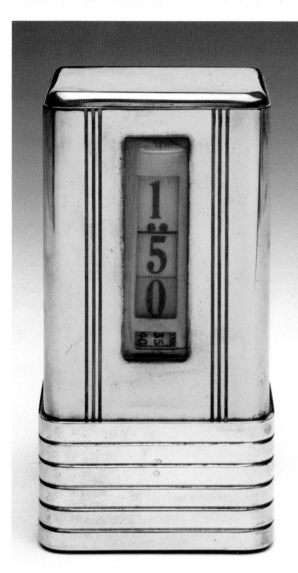

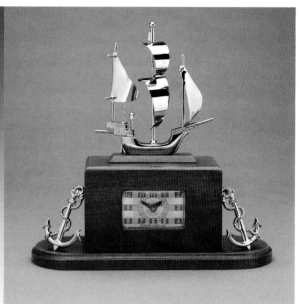

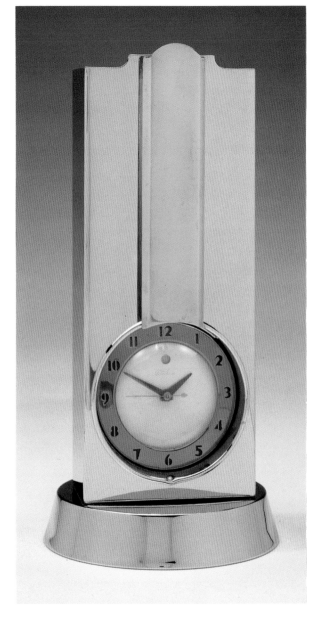

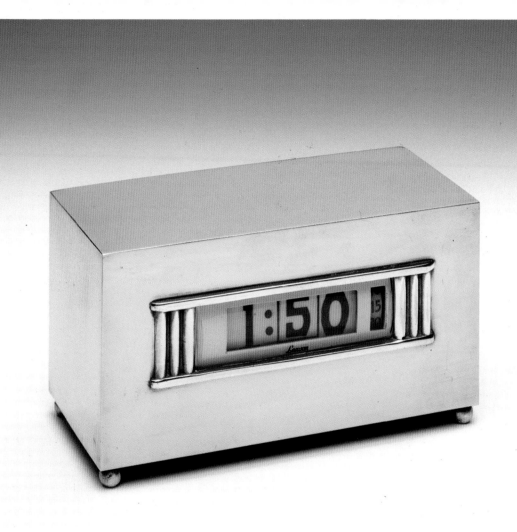

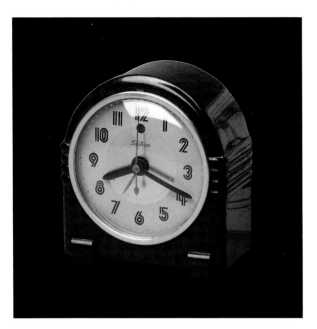

Designed by Frank Green
in 1937 for the Warren
Telechron Company, this
walnut Bakelite clock
(model #7H 79), was
copied by many others
and became a standard
night table design.

Author Collection

Before and after. These
inexpensive flea market
discoveries have been given
a new life. The New Haven
mirrored glass and chrome
mantle clock (TOP) has
been re-silvered and fitted
with replacement hands.
The unusual rotary calendar
clock has an eighty hour
movement and alarm with
controls that are housed
beneath its hinged, domed
bell (BOTTOM). A design

patented by Herbert Lam-
port in 1938, the model
was available in three colors:
Chinese red, bronze, and
ivory. It retailed for $6.95.
The metal housing has been
refinished in chrome and
polished brass.

Author Collection

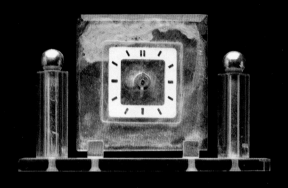
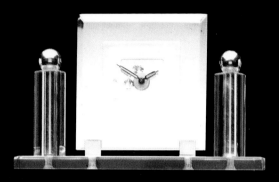
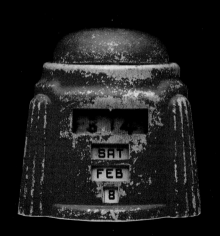
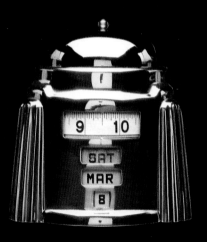

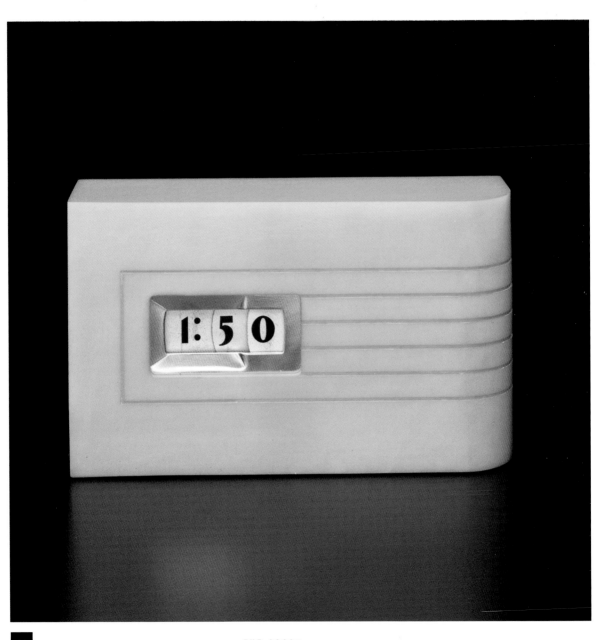

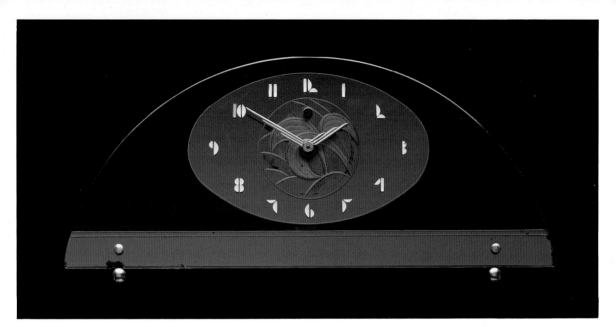

PAGE 54

A Catalin plastic cabinet houses three concentric aluminum wheels rotating on the same axis to produce hours, minutes, and seconds. Adjustment is made by rotating the discs with a pencil eraser. Winslow Manufacturing Company produced this model in a range of swirled colors.

c. 1938.

Bob Breed Collection

ABOVE

An etched-glass floral motif contained in a circle of blue mirror, set within an oval of blue mirror, bordered by numerals in silver relief, and all set within a combination of a blue glass semi-circle with a broad, mirrored base strip in blue, mounted on two miniature chrome spheres. An exceptional design from General Electric, c. 1935, for model #6H02.

Courtesy, Harvey's, Melrose Avenue

Selection

1 9 4 0 s

TICK Tock TICK Tock TICK Tock

GOD BLESS AMERICA

when minutes matt~
. . . trust **TELECHRO**~
ELECTRIC CLOCKS

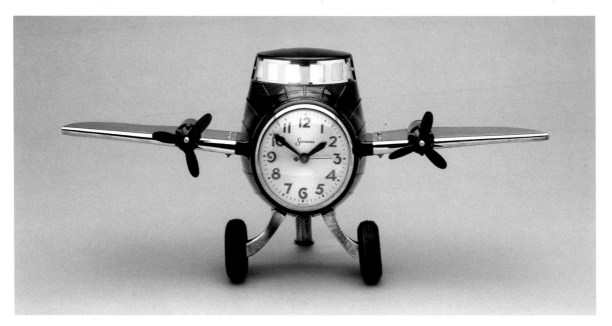

The Sessions "Airliner"
in gleaming aluminum boasts
a wingspan of twenty-one
inches. Tri-blade turning
propellers are wing-mounted
on either side of a walnut
Bakelite cabin, illuminated,
and sporting plastic win-
dows. The chrome landing
gear and balloon tires
in fine detail make the
manufacturer's suggested
retail price of $15.75
entirely reasonable for 1947,
its year of introduction.

Courtesy, Piccolo Pete's,
Sherman Oaks

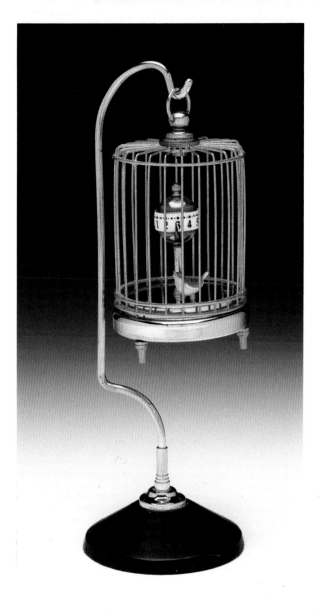

A wind-up bird in a gilded
cage. This late forties
Japanese export features a
dipping bird beneath a gold
orb, girded with a time
tape. A pointer remains
in a fixed position while
the ball revolves, indicating
approximate time.

Peter Linden /
Eric Menard Collection

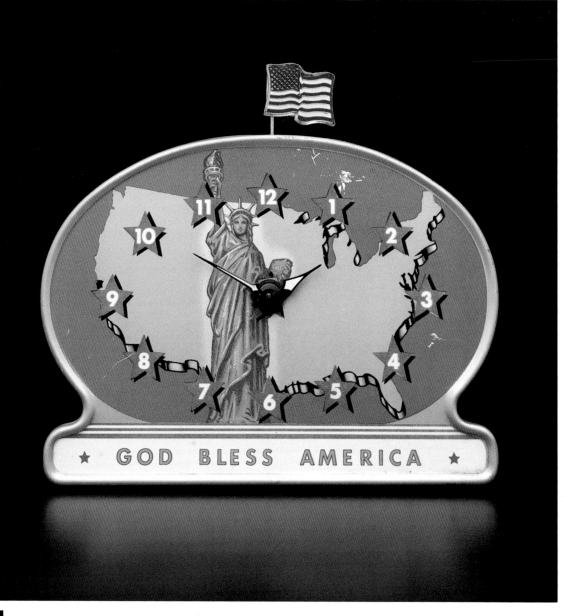

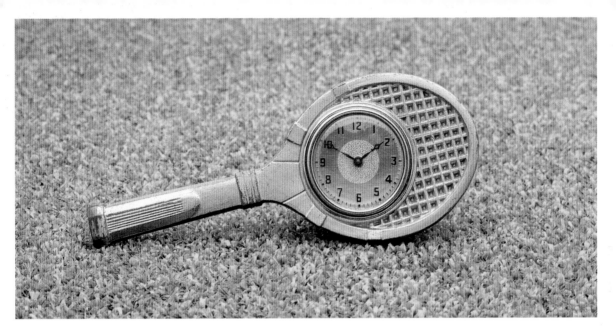

PAGE 62
Commonly referred to
as the "Kate Smith God Bless
America Clock," this low-
cost, pressed-metal-faced
clock found favor with the
patriotic dime store shopper
in 1940. As the clock runs,
a self-starting mechanism
constantly rotates the stars
and stripes.
Author Collection

ABOVE
A pot-metal racquet
measuring ten inches for
the desk of a tennis fan.
The inset clock is by Viking.
This wind-up novelty is
from the forties.
Courtesy, Off The Wall, Los Angeles

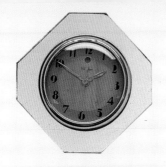

A

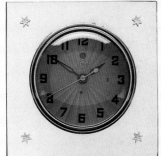

B

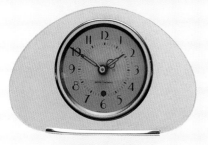

C

D

LEFT

Mirrored clocks for the boudoir or mantle in peach were commom throughout the forties. Inexpensive electrical movements were housed in hundreds of mirrored face shapes that provided an up-market look. It was estimated that every U.S. household owned a minimum of five clocks during this period. A: Warren Telechron. B: General Electric, model #5H64. C: Seth Thomas. D. General Electric, model #7H77.

Courtesy, Regency Jewelry Company, Los Angeles

PAGE 63

Plastic-cased, low-cost wall clocks for the kitchen. Seth Thomas produced a range of "Pippin" clocks (TOP LEFT AND RIGHT) while General Electric Telechron offered a design by Russell Wright (BOTTOM LEFT AND RIGHT). A Jewel "Pin up" clock radio for the kitchen was introduced in 1947 (CENTER).

Courtesy, Harvey's, Melrose Avenue Center: Author Collection

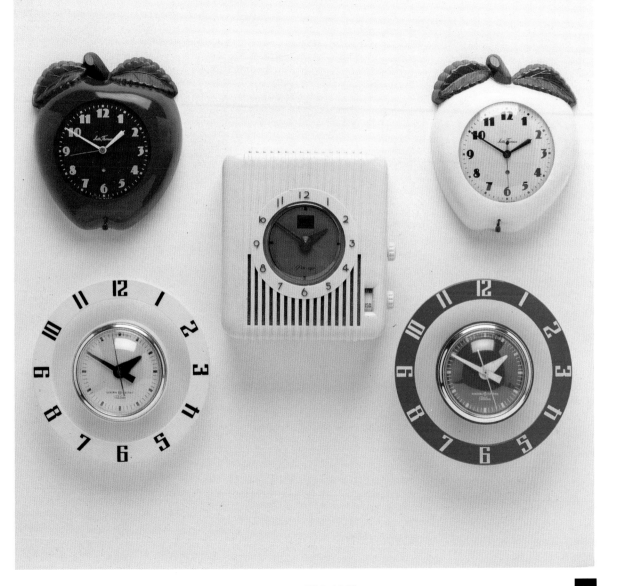

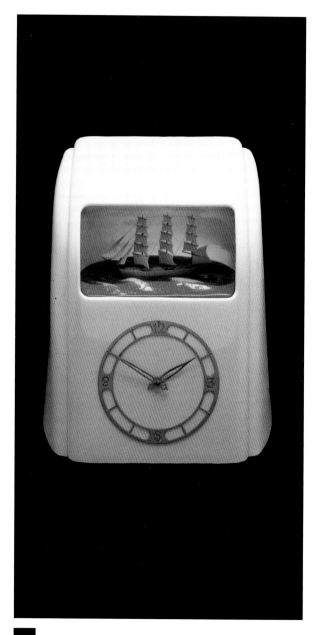

An unusual design in pink urea plastic, manufactured on the Isle of Man in 1947. As time passes, the ship is seen undulating as if in motion on a stormy sea. The sky color alternates from sunrise through a sunny day to a cloudy dusk. The variations are courtesy of a revolving drum of gel colors through which a light is projected to create changes of light in the sky. A product of Vitascope Industries, the clock was made in a variety of color cabinets and two variations of face.

Author Collection

The Tortoise and the Hare legend is illustrated in abbreviated form on the face of this charming children's wind-up alarm from Smith in Great Britain. Familiar farmyard animals punctuate the "milestones" (hours) while the hare on the minute hand races past the tortoise on the hour hand, "Twelve times as fast." Painted metal case with brass-plated trim.

Ben Yellin Collection

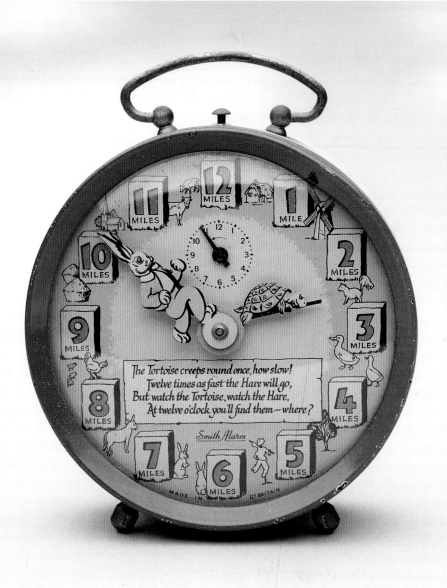

The Tortoise creeps round once, how slow!
Twelve times as fast the Hare will go,
But watch the Tortoise, watch the Hare,
At twelve o'clock you'll find them—where?

Smith Alarm

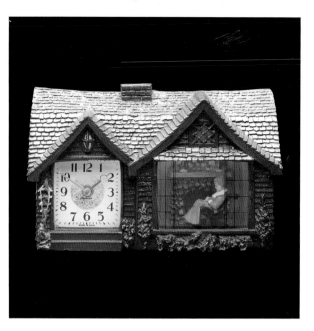

"A Haddon Original,"
this pressed-wood mantel
clock, "Home Sweet Home"
model #30, features an
illuminated granny rocking
the seconds away in front
of a glowing hearth. Haddon
Products, c. 1948.

Courtesy, Harvey's, Melrose Avenue

PAGE 69

When a Buick was a
Buick, a clock compli-
mented the speedometer
in the symmetrically de-
signed, chrome-trimmed
instrument panel. This
one, manufactured by the
George Borg Company
of Chicago, graced the
1949 model.

Author Collection

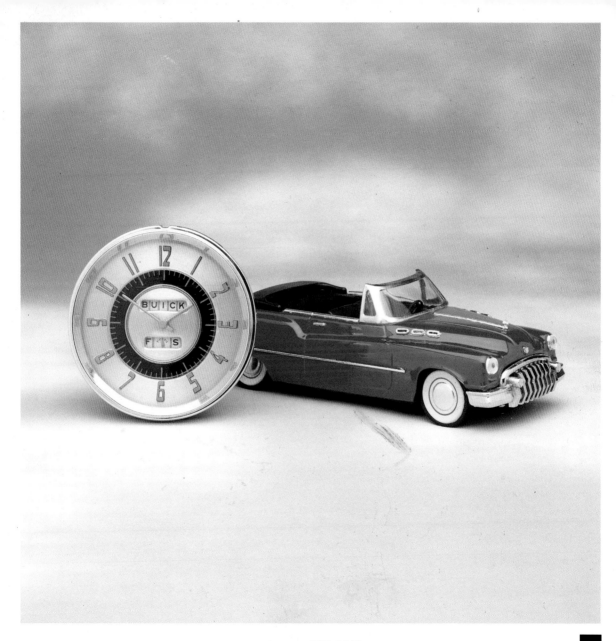

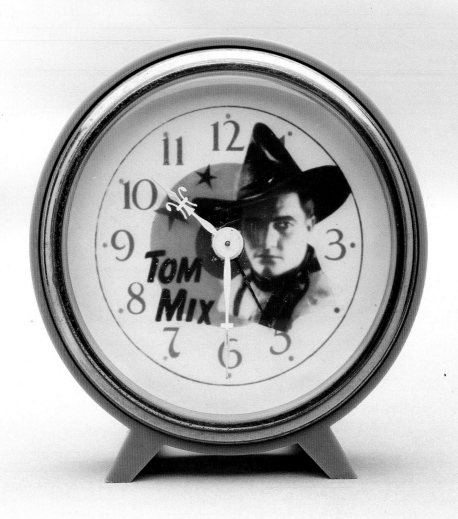

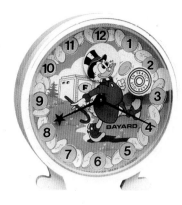

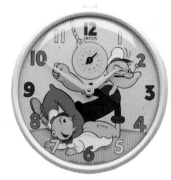

PAGE 70

An inexpensive tabletop
wind-up featuring Tom Mix,
a matinee idol from the
twenties and thirties. Mix
was easily the most popular
cowboy star of his genera-
tion, and this fifties example
of "Mix Merchandising" is
testimony to his enduring
popularity. German manu-
facture in urea plastic.

Ben Yellin Collection

RIGHT

Favorite cartoon characters
depicted on European
clocks. Donald Duck (TOP)
in a plastic-cased French
Bayard clock; Popeye and
Swee' Pea (CENTER); Noddy
and Big Ears (BOTTOM) in
a Smith metal-cased clock
from England.

c. 1950.

Ben Yellin Collection

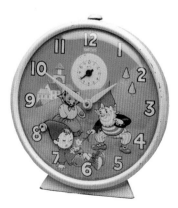

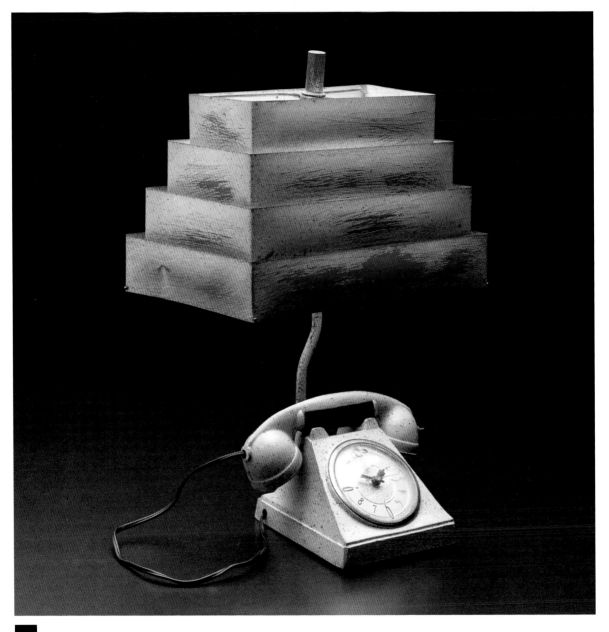

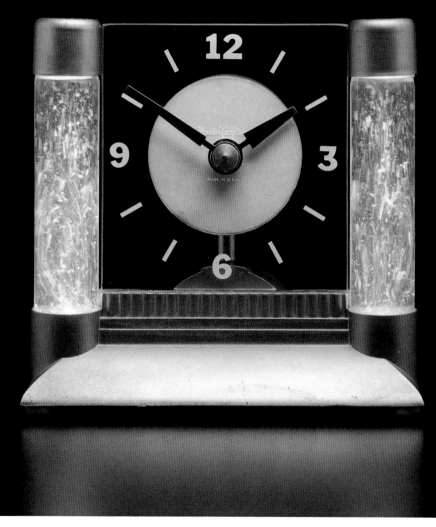

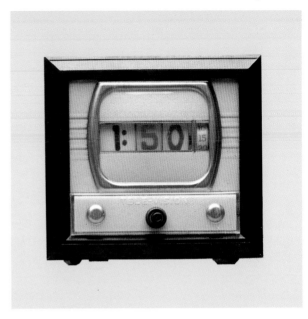

Is it a phone? A lamp? A clock? It is two of the three, plus a cigarette lighter, cunningly concealed in the telephone handset and activated by a small button. This extraordinary combination seems to embody fifties' flamboyance. Made in Brooklyn by The Trea-Boye Corporation, it has become a highly collectible item for afficionados of the era.

Courtesy, Harvey's, Melrose Avenue

A glitter clock for the mantel has two glass pillars containing immersed tinsel shreds. The heat from the illuminated bulbs installed beneath the pillars causes the tinsel to rise and undulate in a slow, constant motion, producing perpetually changing patterns. Manufactured by Mastercrafters Clock Company, this "Action Starlight" model #47 dates from the early fifties.

Courtesy, Wanna Buy a Watch?,
Los Angeles

Tele-Vision by the Pennwood Numechron Company. An inexpensive plastic television-top clock with low voltage illumination, the Tele-Vision clock reflected TV design changes through three decades. Model #4755. This Numechron Tymeter was introduced in 1957.

Bernard Sampson Collection

An elegant design by George Nelson, the "Chronopak" for the Howard Miller Clock Company of Zeeland, Michigan, features walnut spears splayed from a central circular metal case with metal hands in the familiar oval and arrow-point arrangement. Model #4755. **c . 1955.**

Courtesy, Harvey's, Melrose Avenue

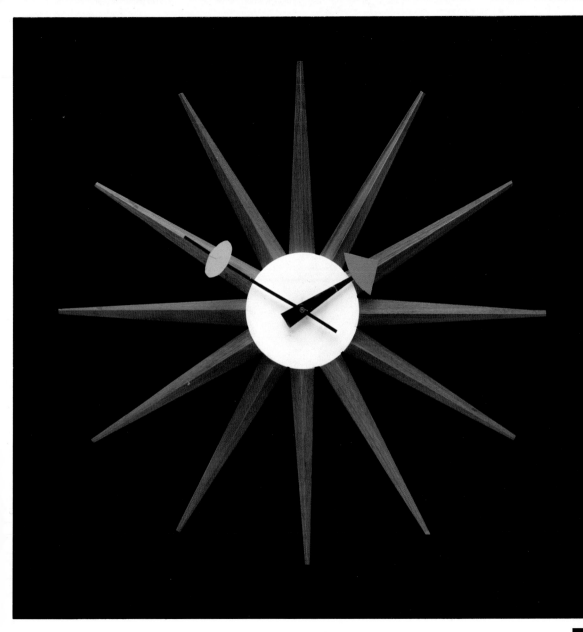

PAGE 76

Illustrated against a hand-painted design on rayon fabric that exemplifies the fifties era, the George Nelson "Steering Wheel" clock, marketed by Howard Miller, retailed at $60.00 in the mid-fifties. The circular metal case and solid metal hands formed the basis of designs accommodating the numerals in a variety of now famous configurations including the "sunburst" and "starburst" wall clocks. Model #4756.

Courtesy, Harvey's, Melrose Avenue

PAGE 77

A brass hoop features balls in two sizes instead of numerals against a starburst design in black fiberglass by an unknown manufacturer. A popular fifties motif that echoed the bold re-introduction of black-colored furnishings into interior living spaces.

Courtesy, Harvey's, Melrose Avenue

ABOVE

A 1950s mantel clock with well-groomed kids swinging in an idyllic country setting. Made in a urea plastic compound by Master Crafters, the clock was produced with a variety of illuminated, animated scenes.

Howard Banta Collection

PAGE 79

Clock radios incorporating timer switches were advertised as multifaceted appliances. "Awakes you gently with music," "Starts the morning coffee," and "Keeps perfect time" are just a few of the claims. The Zenith model #L515, 1952 (TOP) and Crosley model D25BE, 1953, (BOTTOM) were both available in a variety of colors.

Author Collection

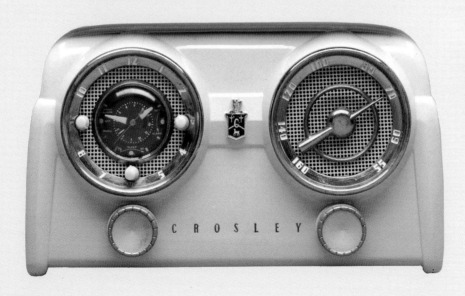

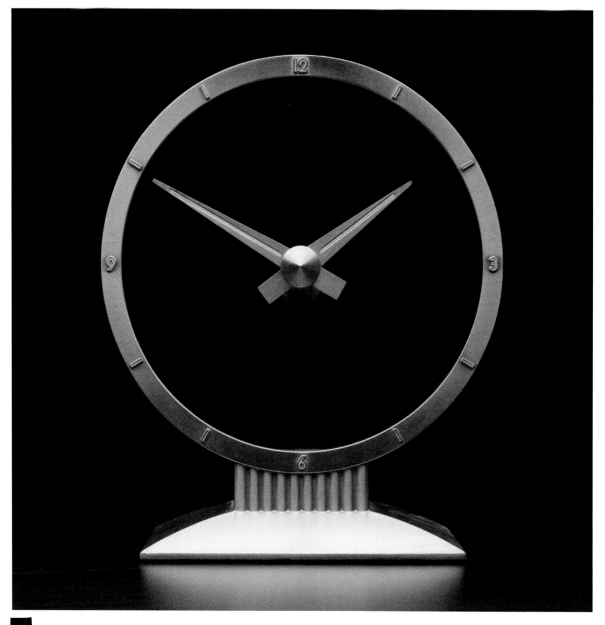

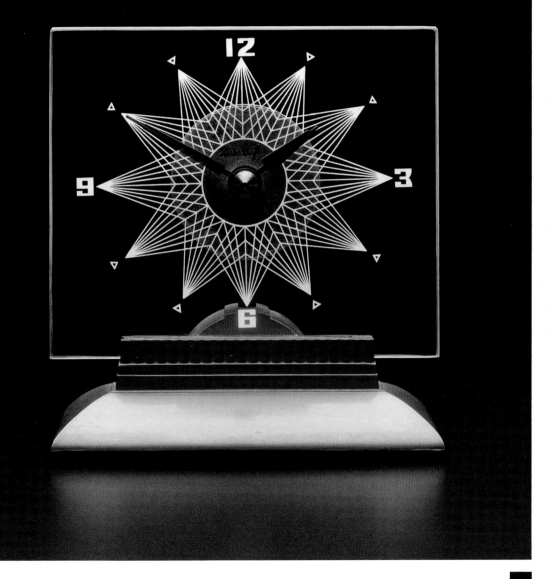

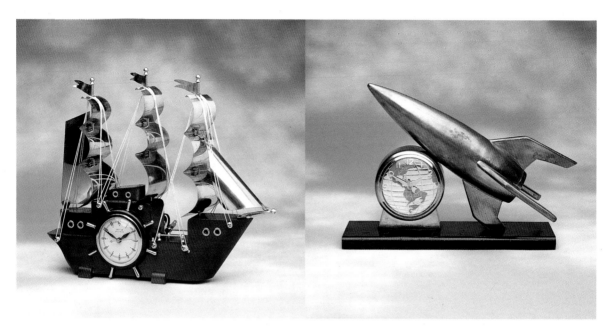

PAGE 80

The Golden House Mystery Clock, manufactured by Jefferson Electric Company in 1956, is a popular visual puzzler. How are the hour and minute hands activated when they appear suspended in thin air? This mystery clock has a synchronous movement with three plates of glass. The middle pane has a metal-toothed rim (ring gear) that is revolved by engaging a cog in the motor that is housed at the base of the clock. This example proved to be the most popular design from an enormous range of "mystery" clocks available in the fifties.

Author Collection

PAGE 81

The "Starlight" by Master Crafters Clock & Radio Company, model #146, features an etched glass face that can be illuminated independently by a con- cealed lamp in the base.

c. 1955.

Courtesy, Regency Jewelry Company, Los Angeles

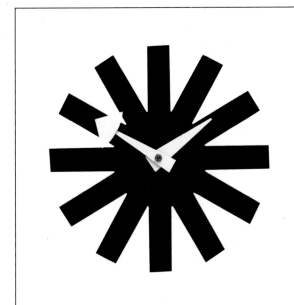

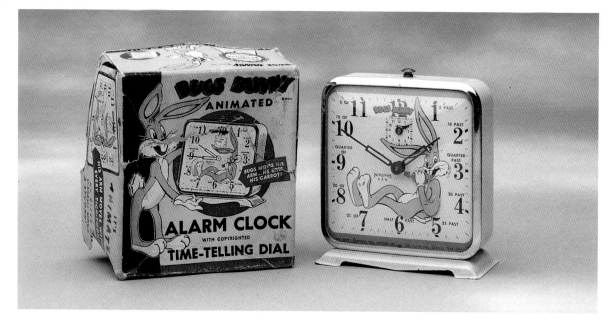

ABOVE

This Bugs Bunny animated wind-up alarm from Ingraham retailed at $3.81 in the late fifties. See Bugs chew on a carrot every other second.

Ben Yellin Collection

PAGE 85

A Lux novelty wind-up alarm featuring a show boat with rotating paddle wheel. Metal-cased, the clock retailed at $3.60 in 1956.

Ben Yellin Collection

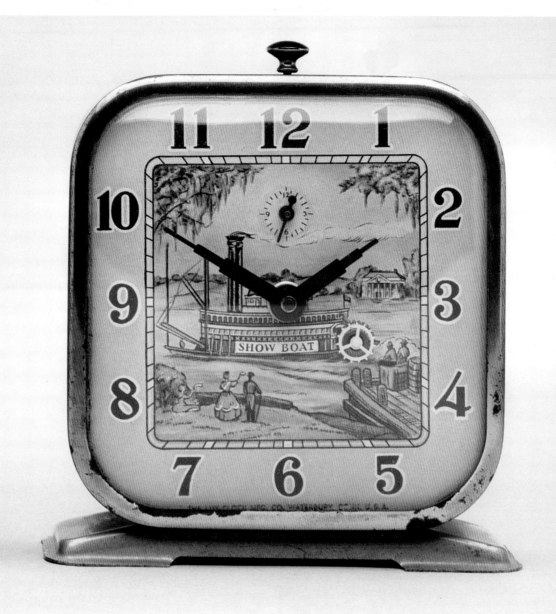

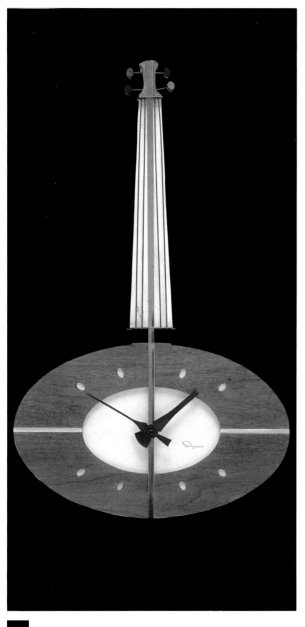

A wood and brass-trimmed
balalaika in a simple stylized
simulation by Ingraham
for the wall of the contem-
porary living room of the
hip fifties home.

Courtesy, Harvey's, Melrose Avenue

A Japanese plastic-cased
fifties-style musical
alarm clock by Toyo Clox.
Wind-up mechanism.

c. 1956.

Author Collection

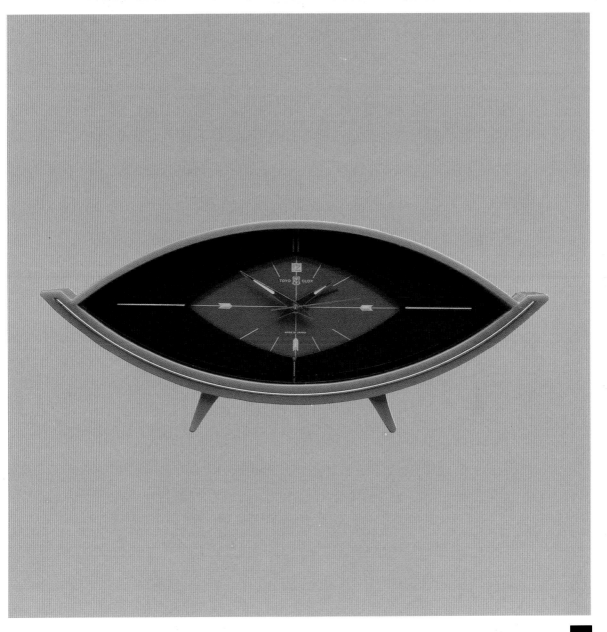

1960s

peter max

Clocks

TICK TOCK TICK TOCK TICK TOCK TICK TOCK

DAISY REFLECTION

contemporary
and exponent
of the color explosion is
famous for his posters, table-
ware, linens, glassware...and,

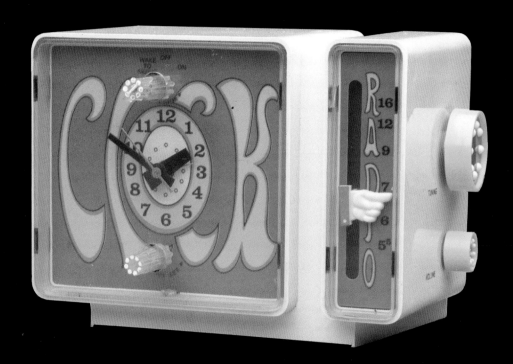

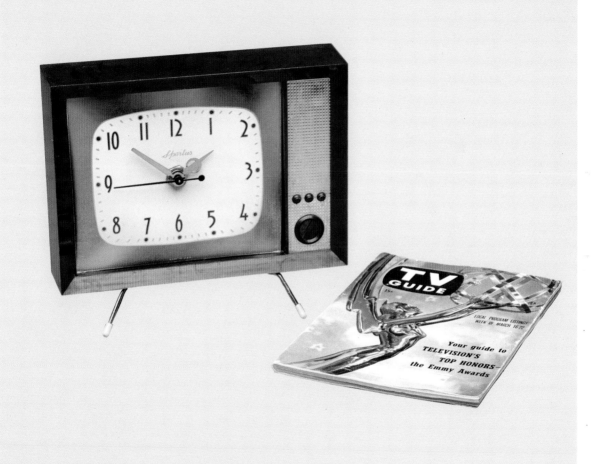

PAGE 90

From the decade of Peace and Love, a Peter Max–inspired Clock Radio marketed by General Electric and made in Hong Kong. Themes and motifs of the sixties were projected through the prolific designs of Max. The option of having an alarm wake you to your favorite AM station is a standard feature.

Author Collection

PAGE 91

An inexpensive plastic table or desk clock by Herold Products. The "Spartus" is styled like a table-model television from the early sixties.

Bernard Sampson Collection

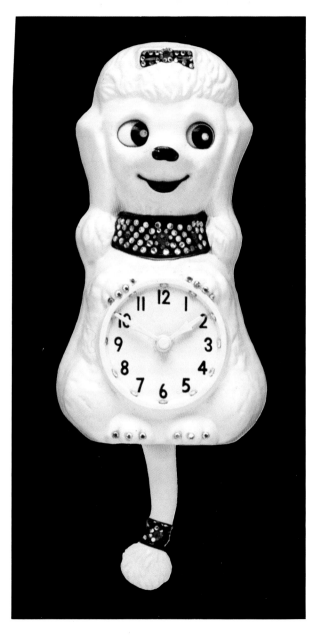

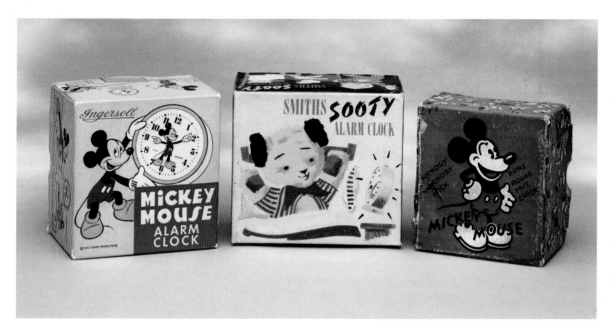

PAGE 92

The poodle wall clock, a perennial favorite—together with its black feline counterpart—features wide-eyed movement synchronized with a wagging pendulum tail. Inexpensive plastic case variations of the diamante-decorated smiling dog have endured since the mid-thirties. This example is manufactured by The California Clock Company.

c. 1965.

Courtesy, Harvey's, Melrose Avenue

ABOVE

The phenomenon of enhanced value of certain collectibles by the addition of original packaging is valid for character and novelty clocks. Mickey Mouse, American (LEFT) and English (RIGHT), flanks Sooty (CENTER), an English TV glove puppet from 1960. Specialized services are available to restore boxes to their original condition. The examples illustrated are original and especially valuable to the purist.

Ben Yellin Collection

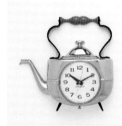

LEFT

Kitchen wall clocks have been offered in many variations of culinary paraphernalia from chef's hats to knives and forks for hour and minute hands. Pots, pans, fruits, plates, and menus have all graced kitchen clocks. This example of compression-molded plastic in the form of a turn-of-the-century kettle is a modern, battery-driven equivalent of a popular design that has endured through ninety years. General Electric model #2135.

Diane Janah Collection

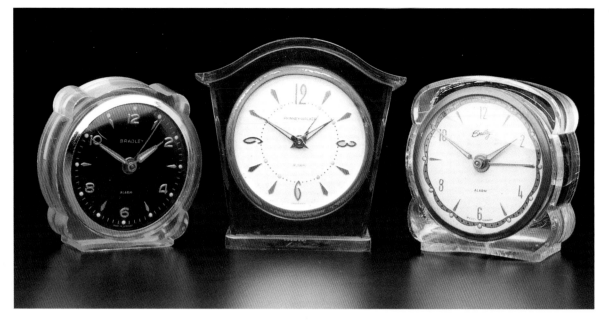

Three inexpensive Lucite table clocks for the boudoir. Manufactured by Bradley (LEFT AND RIGHT) and Phinney Walker (CENTER) in Germany, these wind-up alarm clocks feature luminous hands and hour spots. They offer side views of the mechanism through the plastic.

c. 1965.

Author Collection

A beautiful wind-up from Bayard, France, "Blanche Neige" (Snow White) features the seven dwarfs and other furry forest creatures from Walt Disney. An animated bluebird hovers at her right hand. The classic 1938 feature-length cartoon has enjoyed global merchandising throughout its fifty-five-year history. Bayard produced many Disney character clocks for its domestic market. This model was introduced in 1969. Metal case.

Courtesy, Off The Wall, Los Angeles

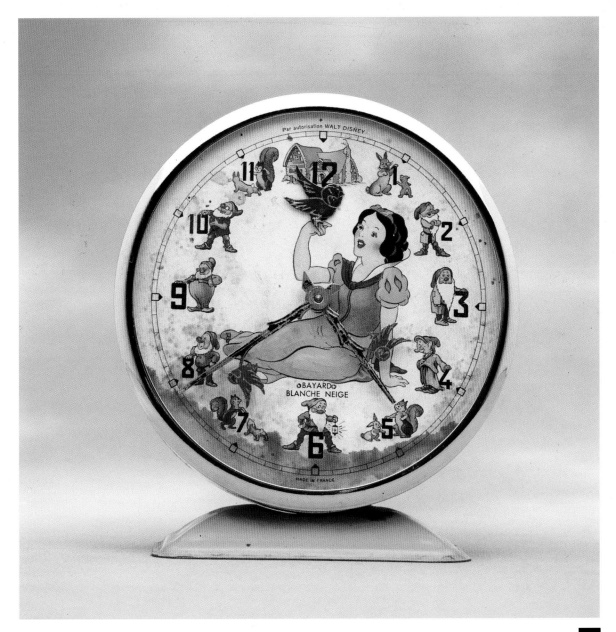